TAYLOR MCNEE

ART PROMPTS

IDEAS TO GET YOU STARTED

PORTICO

CONTENTS

WELCOME TO ARTPROMPTS

The idea for Artprompts.org came to me out of necessity. I have always enjoyed drawing, but sometimes, I have found, it can be hard to sit down and focus when you don't have any fun ideas for subjects.

Stuck for inspiration one day, I thought, 'Wouldn't it be cool if there was some kind of prompt generator geared specifically for artists.' I looked around online, couldn't find any, so I decided to make one. My goal was to amass a huge variety of imaginative and well-written prompts for people to click through to find some inspiration for their sketchbooks, and so Artprompts.org was created. Now, this wonderful little book has followed in its footsteps.

The Artprompts book is perfect for anyone who loves to draw or who wants to improve their drawing skills. All skill levels are welcome, from those brand-new to drawing and looking for some direction, to seasoned artists struggling with 'artist's block'. Let's face it, there is always room to improve, and the best way to improve a skill set is through active practice. In these pages you will find informative articles, useful examples, inspirational prompts and draw-your-own exercises.

I want to motivate you to pick up a pencil and draw. The prompts I have included are designed to challenge your skills, captivate your imagination and push you out of your comfort zone.

HOW TO USE THIS BOOK

Each chapter starts with one or more articles and exercises designed to help you to improve your drawing skills in five key areas: characters, creatures, objects, environments and situations. Read the information, then draw some prompts!

Feel free to mark this book up and treat it like a sketchbook. There are lots of interactive art pages for you to complete and I encourage you to doodle in its margins as the inspiration takes you.

There is no need to be stick too rigidly to the prompts; they are there to inspire you, not hold you back.

For example, take the prompt: 'A woman with an unusually ornate braid.' If the 'unusually ornate braid' part piques your interest, but you think it would be fun to draw a man with a huge braided beard instead, do it!

Feel free to interpret the prompts as you please, but do challenge yourself. Let yourself be pushed out of your comfort zone as you try new things.

The only way to get better at something is through practising it. This book is here to give lots of fun ideas to make sure that your drawing practice is never boring.

HOW TO BECOME A BETTER ARTIST

The secret to becoming an incredible illustrator isn't actually a secret at all. In fact, it is a piece of advice that seems annoyingly prevalent at times, and which can be applied to a wide range of endeavours, not just to art. It is advice that is given to those who wish to become all-star athletes, incredible musicians, fluent linguists, straight-A students, amazing artists and a seemingly endless variety of other skill sets. Are you ready for it?

Practice makes perfect.

Disappointed? You have probably heard this advice a hundred times before, but what does this somewhat vague expression mean? How does it actually work? How can this simple phrase be the solution to the grand ambitions of so many people?

HOW OFTEN SHOULD YOU PRACTISE?

In his fascinating book *Outliers: The Story of Success*, author Malcolm Gladwell puts forward the 10,000 hours rule, his concept that 10,000 hours is the amount of practice needed to become an expert at something. Not just 'good' but expert, as in one of the best in the world. He claims that there is no such thing as natural talent, and that the key to high levels of talent is just a matter of mindfully practising a specific skill set for an incredibly long period of time.

Now 10,000 hours is a lot of time. You would have to draw for eight hours a day for over three years to achieve that target. But remember, Gladwell is talking about becoming one of the best in the *world*. What if you just want to be a really good artist – good enough to stand out amongst your peers, to have dynamic and intriguing characters, or to be able to illustrate that graphic novel you've been writing?

Let me clarify something: you don't need to practise for 10,000 hours to become a good, or even a great, artist. You just need to start . . . NOW! To become stronger in an area in which you are weak, you need to deliberately and mindfully exercise your skills. Instead of fearing the unknown, why not take the time to learn? Yes, it may be confusing and frustrating, but the end result will be worth it.

I recommend you make your own 'hours-spent' goal. Why not try 100, or maybe 500 hours, to start with? Use plenty of references and resources and I guarantee you will see progress as you learn and grow.

MAINTAINING YOUR MOTIVATION

Have you ever felt so excited to learn something new that you just couldn't wait to work on it? After picking up a new hobby or deciding to learn a new skill, you are often overflowing with inspiration and motivation, which are very powerful tools when it comes to learning.

Then after a few months, or weeks, or even days, your enthusiasm starts to wane. The new guitar sits unplayed in the corner of the room. The gym membership goes unused. The sketchbook you bought to be filled with drawings gets filed on the bookshelf and forgotten.

This all-too-common scenario happens because motivation is hard to sustain, especially when your practice starts to lose its novelty or your goals get harder. You may still *want* to get better, but you no longer *feel* like setting aside time in your busy day to enable you to do so.

If you want to be a great artist, how can you push through your 'artist's block' to continue to practise and learn? The key is to acknowledge that your start-up motivation is waning, and instead of letting the project fail, you must remain *disciplined*. If motivation is what makes you pick up your pencil in the first place, it is discipline that will carry you through the project once the initial rush of enthusiasm fades away.

'Every single day, you're the result of what you did on the days prior . . . You can start turning yourself into who you want to be based on what you decide to do today.'

– Chris Hadfield (NASA astronaut)

TIPS TO KEEP YOURSELF MOTIVATED THROUGH DISCIPLINE

Set your end goal Do you want to be able to draw great-looking characters with no reference? Do you want to master perspective? Illustrate a graphic novel? Knowing your goal will help you to better focus your daily practice time.

Write it down Your goal is just a fleeting thought until you commit it to paper; tape it up somewhere where you will see it to act as a constant reminder.

Build daily habits Draw every day, whether you feel like it or not. Even if it's just for 10 minutes, anything is better than nothing. Choose a prompt and draw it. Pretty soon, you won't have to make yourself draw every day; it will have become a habit – something you do without even thinking about it.

Minimise distraction During your daily practice, mute your phone, turn off the television and close the internet tabs. Set a timer to keep your attention focused on your goal during your practice time.

Improving is hard. Going from a beginner guitarist to rock star is hard. Getting super fit at the gym is hard. Becoming an amazing artist is HARD. If you rely on motivation, on 'feeling' like doing something that is difficult, you most likely never will. You must hold yourself accountable by cultivating a disciplined approach. Eventually the results you see will make you feel like continuing on your creative journey.

CHARACTERS

BASIC BODY CONSTRUCTION

The adult human body follows some specific proportional rules, as explained overleaf. There can be significant variation in body proportion between different people, but all bodies fit within a fairly standard range.

One of the fundamental skills in drawing people is understanding the relative lengths and sizes of various parts of the body. It is crucial to grasp this basic structure if you want to be able to draw consistent and lifelike figures. Proportions don't have to be 100 per cent realistic in your drawings, in fact most characters in popular comics and manga are often exaggerated; however, even incredibly stylised characters, exaggerated as they may be, loosely follow the rules of body proportion.

For example, a mighty superhero or monstrous villain may be drawn to be above average in height, with broader shoulders and exaggerated muscles.

Even though the superhero or villain is drawn taller, the rest of his body still needs to stay in line with the general rules of body proportion. If his arms are drawn too short in relation to the rest of his body, he will look strange, or even comical.

Manga artists often exaggerate a character's body proportions. An example of this would be a slim, high-school heroine drawn with an exaggerated leg length. It is fine to stylistically emphasise the legs, but if her knees are in the wrong place, it will be noticeable and look 'off'.

Stylising your drawings is perfectly fine (and can be fun!), but it is important to have an understanding of realistic human proportions and anatomy before trying to exaggerate your drawings too much.

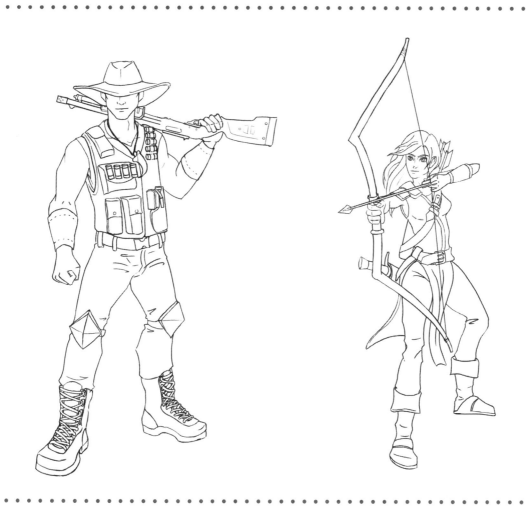

RULES OF BODY PROPORTION

Learning to draw the human figure takes a lot of practise, but understanding some basic proportional rules will help the process along.

THE MALE FIGURE

The body can be divided into eight equal parts, each unit being the height of the person's head.

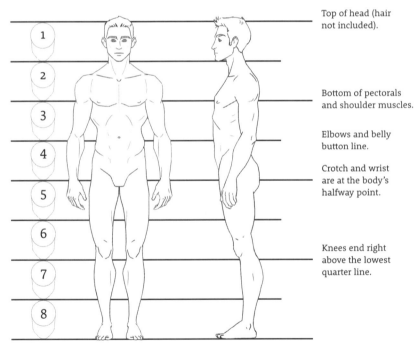

1
2
3
4
5
6
7
8

Top of head (hair not included).

Bottom of pectorals and shoulder muscles.

Elbows and belly button line.

Crotch and wrist are at the body's halfway point.

Knees end right above the lowest quarter line.

12

THE FEMALE FIGURE

Female structure is somewhat smaller than that of males, but the same proportional rules still apply.

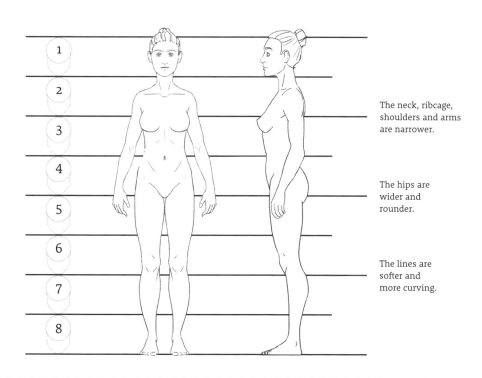

The neck, ribcage, shoulders and arms are narrower.

The hips are wider and rounder.

The lines are softer and more curving.

DRAW YOUR OWN FIGURES

Now that you have learnt how to properly proportion a human body, try drawing your own figures using the grids supplied here, and using the examples on pages 12–13 as reference. Make copies of the grid and try again. Remember, repetition can only make you better.

BASIC HEAD CONSTRUCTION

Whether you choose to draw heads and faces that are realistic or incredibly stylised, it is important to understand the basic rules of face structure to create 'real' characters. For example, manga characters might have larger, more exaggerated eyes, but they still need to be located in the correct part of the face.

On the next few pages, you'll find basic step-by-step mapping for male and female face proportions for front, side and three-quarter views. Practise and memorise these basic rules, then apply them to your own character drawings using the grids on pages 19, 22 and 23.

RULES OF HEAD PROPORTION FRONT VIEW

Step 1 Draw a circle, then divide it in half vertically and horizontally. This represents the upper part of the head.

Step 2 Add the lower part of the head (jaw and chin). The upper head 'circle' is twice the height of the lower face. Divide the head into equal thirds; use these lines to place the facial features (see step 3).

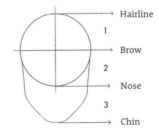

Hairline

1

Brow

2

Nose

3

Chin

Divide the head into equal thirds.

Step 3 Place the features.

Extend top of head slightly above hairline.

Place ears in middle third of face.

Divide lower third of face into thirds. Place mouth opening on first 'third' line.

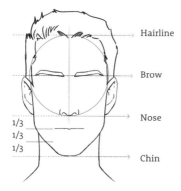

Hairline

Brow

1/3
1/3
1/3

Nose

Chin

Step 5 The basic proportions of the male face complete.

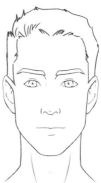

Step 4 Make sure you get the feature proportions right.

There is one eye-width of space between the eyes.

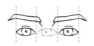

The nose is as wide as the space between the eyes.

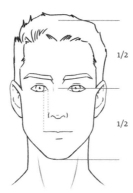

1/2

1/2

The centre of the eyes lie on the midpoint measuring from the top of the head to the chin.

The corners of the mouth extend to the inner edges of the iris.

THE FEMALE HEAD

Female heads follow the same proportional rules as
applied to male heads, but the lines are softer and
not as angular.

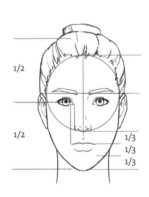

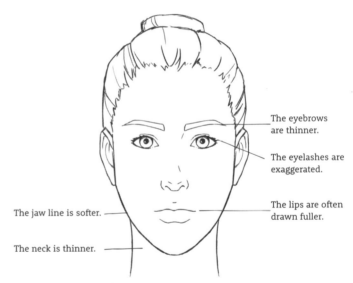

The eyebrows
are thinner.

The eyelashes are
exaggerated.

The jaw line is softer.

The lips are often
drawn fuller.

The neck is thinner.

DRAW YOUR OWN HEADS
FRONT VIEW

Use these guideline diagrams to get you started, referring back to the previous pages as often as you need to. When you are done, draw your own circle and start again. It takes a few tries to memorise the proportions, so have a few goes.

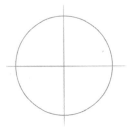

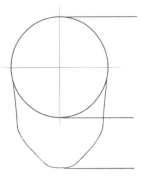

RULES OF HEAD PROPORTION SIDE VIEW

Now that you have had some practise finding the correct proportions for the front view of the face, let's try the side view or 'profile'. The same rules for the front view apply, but here is a slightly different (and slightly quicker) way of finding those same proportions for this angle.

Step 1 Draw a basic head shape like a crash test dummy.

Step 3 Find the brow line and hairline by re-dividing the face into thirds as shown, then flesh out the features.

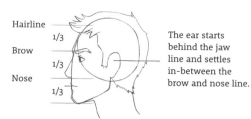

Hairline — 1/3
Brow — 1/3
Nose — 1/3

The ear starts behind the jaw line and settles in-between the brow and nose line.

Step 2 Measuring from the top of the head to the bottom of the chin, find the halfway point – this is the eye line. The nose lies halfway between the eye line and the bottom of the chin.

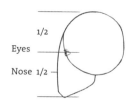

1/2
Eyes
Nose 1/2

Step 4 Add a few more details to complete the side view.

THE THREE-QUARTER VIEW RULES

Now it is time to try the three-quarter view, with the head posed about halfway between the front and side views. The basic structural principles are the same, but now you have to think of the head in a three-dimensional way.

Step 1 Start with a circle and draw your face's midline. Make a mark where the chin will be.

Step 4 To place the rest of the features, divide the face into thirds measuring from chin to hairline.

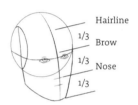

Hairline
1/3 Brow
1/3 Nose
1/3

Step 2 As the sides of the head are actually flat, it can be helpful to 'chop' off the sides of your sphere as shown.

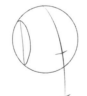

Step 5 Place the rest of the features and refine the face.

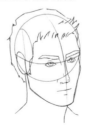

Step 6 The completed three-quarter view.

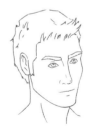

Step 3 Add the lower jaw. To find the eye placement line, divide the head in half.

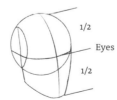

1/2
Eyes
1/2

DRAW YOUR OWN HEADS
SIDE AND THREE-QUARTER VIEWS

Here are a few shapes to get you started. Use the crash test dummy shape (below) to create a side view head and use the circle with a midline (opposite) to create a three-quarter view head. Once you are satisfied with these drawings, use the blank space to start from scratch and try again on your own. Don't forget to reference the information on pages 20–21 if you get stuck.

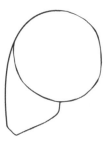

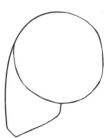

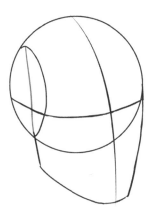
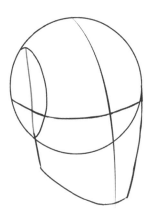

BASIC HAND CONSTRUCTION

Hands are easily one of the most difficult parts of the human body to master. Instead of being composed of one or two big parts, they are made of lots of smaller parts working together, and they can take on countless different shapes. The best way to learn how to draw the hand is to break it down into simplified shapes, then study how each part works.

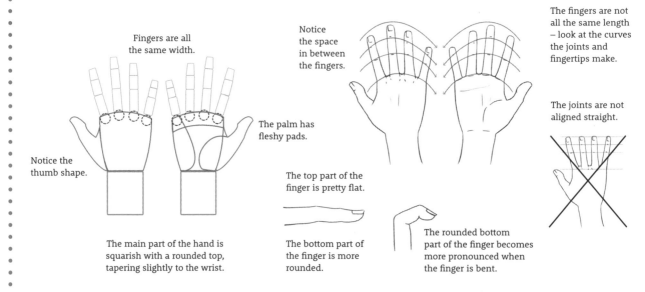

Fingers are all the same width.

Notice the space in between the fingers.

The fingers are not all the same length – look at the curves the joints and fingertips make.

Notice the thumb shape.

The palm has fleshy pads.

The joints are not aligned straight.

The top part of the finger is pretty flat.

The main part of the hand is squarish with a rounded top, tapering slightly to the wrist.

The bottom part of the finger is more rounded.

The rounded bottom part of the finger becomes more pronounced when the finger is bent.

POSING HANDS

It takes a lot of practise to get hands right. Take the time to study how the hand moves and works from observing your own (the one not holding your pencil!). Here are two common poses to get you started.

RELAXED

The fingers curl inwards slightly on a relaxed hand.

FIST

Notice the angle.

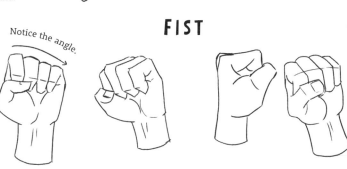

DRAW YOUR OWN HANDS

The only way to master drawing hands is by drawing lots of them (imagine that!). Use this basic hand shape to get started, and start by drawing the fingers and thumb. Remember to pay attention to the way the finger joints curve. Use your own hand as reference.

Fill this page to sketch out a few hand poses, then draw some more in your sketchbook!

POSING YOUR CHARACTERS

Now that we have covered basic human proportion and the construction of the head and hands, you are nearly ready to delve into drawing your own characters. There is one more important step to cover, and that is poses. A good pose will add life and personality to your characters, and can make them look much more interesting.

When initially drawing a character or practising poses, simplify the body down to its basic shape, much like a stick figure or a mannequin. Don't worry about adding too much detail at this stage. Keep your drawings quick and loose and aim to keep the proportions accurate.

Break the body down into rough shapes. Avoid straight lines when drawing the poses as they can make your characters appear stiff. (A helpful tip: when drawing the hips, it can be helpful to think of them as underwear bottoms!)

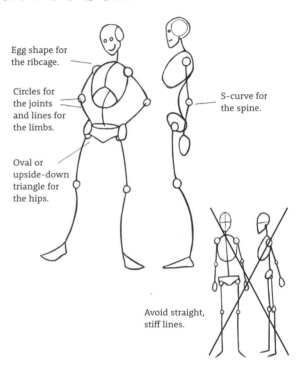

Egg shape for the ribcage.

Circles for the joints and lines for the limbs.

Oval or upside-down triangle for the hips.

S-curve for the spine.

Avoid straight, stiff lines.

Look at lots of reference and draw plenty of quick, simple gestures to get great at posing your characters.

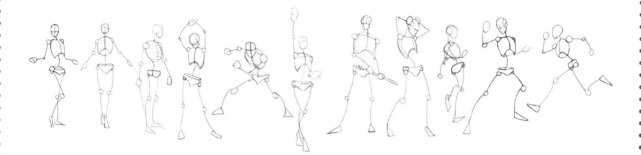

When you find a pose you like, you can add shape and volume to the simple figure to turn it into a finalised drawing.

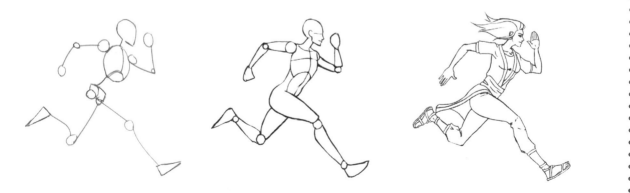

DRAW YOUR OWN POSES

It's time to take a shot at posing a character, starting with a standing pose and a running pose. To help you with drawing your first poses, I have supplied you with some basic torsos. All you have to do is add on the limbs. Then try drawing some of your own poses from scratch.

A WARRIOR WITH A WILD
MANE OF BLACK HAIR
BARELY CONTAINED
BY BRAIDS.

THE REGAL FOREST KING.

AN ELDERLY WIZARD
WITH A LONG BEARD
AND UNCONTROLLABLE
EYEBROWS.

AN ADORABLE, CURLY-HAIRED TODDLER
HUGGING HER HUGE, HAIRY PET SPIDER.

THE MAN HID HIS HARSH BEARDED FACE AND
HOSTILE BLACK EYES IN THE SHADOW OF HIS
HOODED CLOAK.

A YOUNG BOY WALKING HIS PET MONSTER.

MEDUSA AS A MODERN WOMAN.

AN INFAMOUS PIRATE CAPTAIN.

A BEAUTIFUL GIRL IN THE
UGLIEST DRESS IMAGINABLE.

IF LITTLE RED RIDING HOOD WAS A BOY.

Now imagine Little Bo Peep as a buccaneer.

A STEAMPUNK
BOUNTY HUNTER.

A WITHERED, OLD SHAMAN
TEACHING HIS YOUNG DISCIPLE.

A RUGGED COWBOY AND
HIS TRUSTY HORSE.

A SOLDIER AND HIS
K-9 UNIT.

A BURLY, AXE-WIELDING
LUMBERJACK.

THE GUARDIAN OF
THE WOODS.

AN AFFLUENT WOMAN IN AN
ORNATE VICTORIAN DRESS.

AN ARCHER WITH BOW
DRAWN, READY TO STRIKE.

A FUTURISTIC POLICEMAN
IN SLEEK RIOT GEAR.

A PROFESSIONAL
WEREWOLF HUNTER.

A GRIFFIN RIDER
AND HIS STEED.

A DELICATE FAIRY.

THE ROYAL
DRAGON GROOMER.

A MASKED VIGILANTE.

A CYBERNETIC SOLDIER.

THE SHIELD MAIDEN'S
FLAXEN HAIR TUMBLED
ACROSS HER SHOULDERS.

A FIERCE GLADIATOR CHAMPION.

Draw the woman of his dreams.

A GLOVED, MASKED THIEF.

A WITCH AND HER
ANIMAL COMPANION.

A SORCERER OF
DARK MAGIC.

IDENTICAL TWINS OF DIFFERENT GENDERS.

———————

A DANGEROUS-LOOKING WOMAN
WITH THICK DREADLOCKS.

———————

A YOUNG BOY WITH WILD HAIR
AND EVEN WILDER EYES.

QUEEN OF THE DWARVES.

A BLACKSMITH WITH
MUSCULAR ARMS COVERED
IN INTRICATE TATTOOS.

A POMPOUS ELVEN KING
WITH COLD, GREY EYES.

A BOY WITH WINGS.

A PUNK-ROCKER CHICK WEARING
A LEATHER JACKET.

A COMICALLY DISPROPORTIONATE
BODYBUILDER.

A CRUEL QUEEN LEERING
DOWN FROM HER THRONE.

A HUNTER WITH HIS
SHARP-EYED FALCON.

A BARD AND HIS
CHOSEN INSTRUMENT.

Draw a warrior capable of battling the mighty Minotaur.

ONE OF THE FOUR HORSEMEN
OF THE APOCALYPSE.

A SPACE PIRATE WITH
CYBERNETIC IMPLANTS.

AN OMINOUS, ARMOURED FIGURE
ASTRIDE A MASSIVE BLACK STEED.

A HITCHHIKER WHO NO RIGHT-MINDED PERSON WOULD PICK UP.

A WATCHFUL SHEPHERD CARING FOR HIS FLOCK.

THE GIRL BUNDLED HER THIN FRAME INTO A COMFY, OVERSIZED SWEATER.

A MAD SCIENTIST CACKLING MANICALLY.

A FIGHTER WITH WRAPPED HANDS.

AN UNSHAVEN YOUNG
MAN WEARING A HOODIE.

A DRUID WITH A GREAT SET OF ANTLERS.

A GIRL WITH AN ELABORATE TATTOO.

A HUGE MAN WITH A TINY DOG.

A GRUMPY WAITRESS.

AN ELF WITH DELICATE, ANGULAR FEATURES.

A BALLET DANCER IN A STRIKING POSE.

A GREASE-COVERED MECHANIC.

THE CRAZY CAT LADY.

Now that you've met crazy cat lady, have a go at bringing crazy dog guy to life.

A MONSTROUS
PRISON INMATE.

A STEALTHY
HUNTER IN
A FUR HAT.

A PARANORMAL
INVESTIGATOR
COVERED IN
EQUIPMENT.

A FLASHY FASHION DESIGNER.

DAISIES WERE TUCKED INTO THE GIRL'S LONG, FLOWING HAIR.

A DEVILISH PRINCE.

A PALADIN ENVELOPED IN HOLY LIGHT.

A ROCK STAR COVERED IN PIERCINGS.

A SCI-FI MERCENARY IN SLEEK ARMOUR.

A WOMAN IN A SPACESUIT.

A BIKER OUTLAW.

A SKATEBOARDER PERFORMING
A REALLY COOL TRICK.

THE BEAST MASTER.

A SUPERHERO IN A GAUDY OUTFIT.

A STRICT LIBRARIAN WITH HER DARK
HAIR PULLED INTO A TIGHT BUN.

A POST-APOCALYPTIC SURVIVOR.

AN ASSASSIN WITH BLADE DRAWN.

Draw this space explorer's crewmates.

A VICTORIAN-ERA VAMPIRE.

———————————

A FIGHTER WITH LARGE, STRONG
MECHANICAL ARMS.

———————————

AN ARMOURED TOWN GUARD.

A STUDENT OF WIZARDRY DILIGENTLY
STUDYING AN ANCIENT BOOK OF MAGIC.

AN ADVENTURER OUTFITTED
FOR A LONG JOURNEY.

A DANCING GYPSY WOMAN.

CREATURES

UTILISING REFERENCE

Utilising reference is one of the most important things that a beginner artist can do to boost his or her drawing ability. Reference can come from a quick internet search, photos in a magazine, or even looking at yourself in a mirror.

If you think that using reference to draw is somehow 'cheating', you couldn't be more wrong. All professional artists use reference, from painters to comic book illustrators. After all, how are you supposed to be able to draw something well if you never took the time to study it?

To illustrate this idea, I will show how I improved at drawing horses using reference. I was raised around horses, so I am familiar with them and what they look like, but I had never taken the time to *focus* on drawing them before. I had never studied them with the intent to accurately sketch them on paper. Let's start by reviewing a few of my horse sketches done from my imagination with no reference used.

At first glance, these from-my-imagination horses, shown opposite, might look okay to an uncritical eye, but if you look a bit more closely, it is obvious that they are lacking something. The more I look at them, the more they appear like dogs, or maybe even deer. Even though I know what horses are supposed to look like in my mind, I am having some obvious trouble translating this onto paper.

The best way to improve at drawing anything (including horses) is to look up plenty of reference images and to draw from those references.

After spending some time searching and gathering loads of photographs, diagrams and images from the internet, I was ready to fill some sketchbook pages with pony poses, focusing on equine anatomy. Turn the page to see a few examples of my horse sketches, made when I was looking at plenty of reference and actively trying to imitate it.

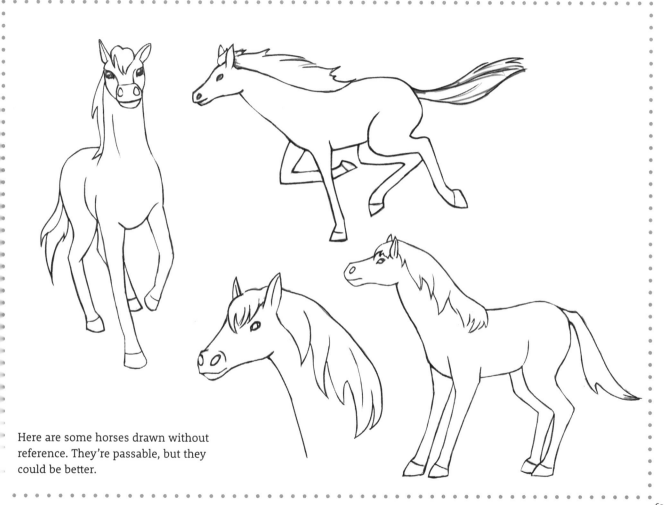

Here are some horses drawn without reference. They're passable, but they could be better.

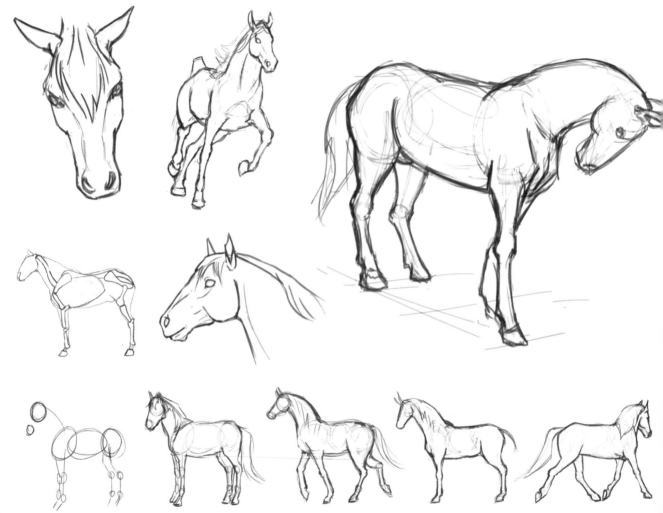

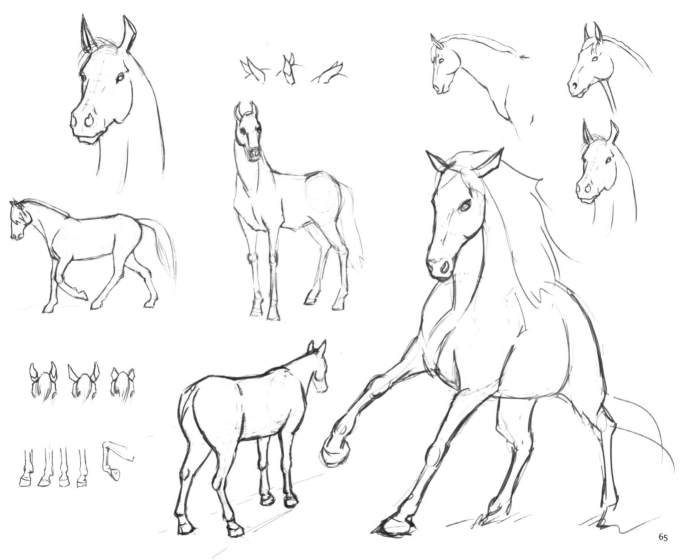

BUILD A LIBRARY
IN YOUR MIND

As you draw from your collection of reference images, It is important never to trace or just to copy the pictures you are working from, but to try to use them to actively *understand* your subject. Learning from reference and not just *copying* is crucial if you want to be able to not only improve your drawing skills, but to become less reliant on reference as you progress on your creative journey.

For example, when I was learning how to draw horses, I kept asking myself questions to keep focused on the learning process, to understand the characteristics of the horse's body rather than to just copy them – questions such as those listed here.

• What are the main features that make a horse look like a horse?

• What are the most important volumes of the body?

• What are the main features of the head?

• How are the joints of the legs positioned?

• What do horses look like if broken down to their most basic shapes?

• How do those shapes work together?

After filling many sketchbook pages with drawings from reference, I finally started to feel like I was understanding horses and how they were built. I felt like I had started to refine them in my mind's 'library', so as a test I tried drawing them from my imagination again. While these may still not be perfect, they do look a lot more like real horses now and less like cartoon dogs with manes! All it took was some patient studying.

As you draw from life and from reference, you will start to build a 'library' in your mind. The more you can add to this visual library, the more versatile the drawings from your imagination will be. You may even reach the point where you no longer feel that you need reference, although I would recommend that you still use it from time to time to check your art is still rooted in reality, no matter what skill level you are.

If there is a subject you want to improve on, get online and find lots of reference, patiently study it, and begin to draw while using that reference as your guide.

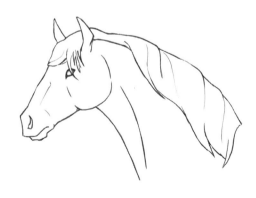

DRAW YOUR OWN CREATURES

Here are two of my horse studies – can you turn them into Pegasus? To create this mythological winged horse, start by studying some real subjects from the natural world. First, fill your sketchbook with lots of different studies of birds' wings, at rest and in flight, then use what you have learnt to bring your Pegasus to life.

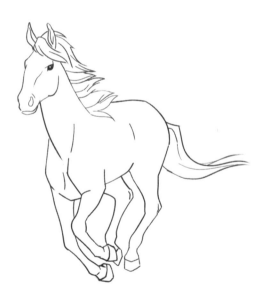

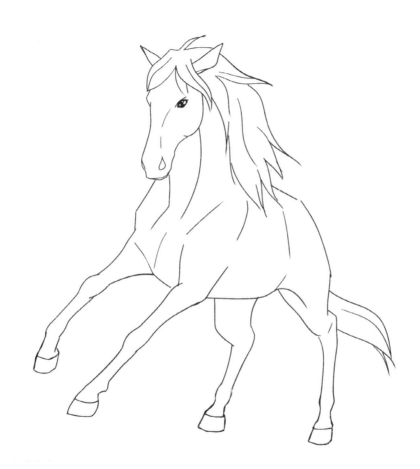

THE ORC BARBARIAN
SNARLED AS HE RAISED
HIS AXE.

THERE APPEARED BEFORE HIM
A CREATURE WITH TINY WINGS
AND A GIANT BODY.

IT WAS A TERRIFYING
EXAMPLE OF ADVANCED
GENETIC ENGINEERING.

ROBOT PUG.

THE BEAST SMILED WIDELY,
FIRE BURNING DEEP WITHIN
ITS MOUTH.

A TRAGICALLY
UGLY UNICORN.

AN AQUATIC DRAGON WITH
FISH-LIKE FEATURES.

A WEREWOLF IN THE MIDDLE
OF A TRANSFORMATION.

THE LEGENDARY NINE-TAILED FOX.

A CENTAUR WARRIOR.

Give these guys some creepy friends.

A COLOSSAL FOREST ELEMENTAL
WITH BARK-LIKE SKIN.

A HELLHOUND MOTHER WITH
HER LITTER OF HELL PUPS.

A BRUTISH ROCK GOLEM.

A MAD SCIENTIST'S
ROBOTIC SHARK CREATION.

A GRACEFUL MERMAID.

A GENTLE NATURE SPIRIT.

75

AN ELEMENTAL WATER CREATURE
BURSTING FORTH FROM THE SEA FOAM.

A MOSS-COVERED BEING EMERGING
FROM DEEP IN THE SWAMP.

A MONSTER CREATED BY
INDUSTRIAL POLLUTION.

A HUNGRY LITTLE BEAST.

AN AGGRESSIVE GUARD DOG.

A HUGE, STURDY WARHORSE.

A DEEP-SEA MONSTER WITH
LUMINESCENT MARKINGS.

A GRIFFIN IN FLIGHT.

A GARGOYLE THAT COMES
ALIVE AT NIGHT.

A FAUN, PART HUMAN
AND PART GOAT, PLAYING
A PAN FLUTE.

THIS CREATURE HAS
LIVED IN THE LIBRARY
FOR CENTURIES.

Draw the fierce beast that battles with this valiant Viking.

A TWISTING,
SERPENT-LIKE DRAGON.

A STRANGE CREATURE IN
THE ANIMAL SHELTER.

THE CAT STARED INTO THE
FISHBOWL, MESMERISED.

A DOG CHASING ITS TAIL.

A GIGANTIC, CLEVER RAVEN.

A FOX IN A TRENCH COAT.

A SHORT, UGLY
DEMON MERCENARY.

A LARGE, INTIMIDATING
MONSTER PICKING FLOWERS.

THE MONSTER UNDER THE BED.

CERBERUS, THE THREE-HEADED
GUARDIAN OF THE UNDERWORLD.

FARMYARD ANIMALS THAT HAVE
BEEN EXPOSED TO RADIATION.

THE SPAWN OF AN
ANGEL AND A DEMON.

A LITTLE TROLL GIRL.

A SINISTER WRAITH
WITH GLOWING, RED EYES.

PEGASUS, THE IMMORTAL
WINGED HORSE, WITH ITS
POWERFUL WINGS UNFURLED.

A SMALL, MISCHIEVOUS IMP.

A FLAMING PHOENIX.

Draw a whole farmyard of animals to keep this lonely sheep company.

BELOW THE NECK, THE LOCH NESS MONSTER IS NOTHING LIKE WE'VE IMAGINED.

A HUGE HERD OF FLUFFY SHEEP GRAZING ON A HILLY LANDSCAPE.

A SHAGGY YETI.

A MONSTER HATCHLING EMERGING FROM ITS EGG.

A TINY, DELICATE DRAGON THAT COULD FIT IN THE PALM OF YOUR HAND.

A CYBERNETIC TYRANNOSAURUS REX.

KITTENS
IN MITTENS.

———

AN ARMOURED
RABBIT KNIGHT.

———

THE BIG
BAD WOLF.

AN AMORPHOUS, TRANSLUCENT
SLIME MONSTER.

A COLOSSAL, HULKING OGRE
CLUTCHING A SPIKED CLUB.

THE TRIBE OF THE
LIZARD PEOPLE.

A WINGED DEMON
WITH ENORMOUS,
CURVING HORNS.

PART HUMAN, PART
SABRE-TOOTH TIGER.

A CARNIVOROUS
PLANT MONSTER.

Complete this alien's body.

A BABY WEREWOLF'S
FIRST TRANSFORMATION.

THE ALIEN CAPTAIN
OF A SALVAGE SHIP.

THE LION GLARES AT ITS PREY
THROUGH THE TALL GRASS.

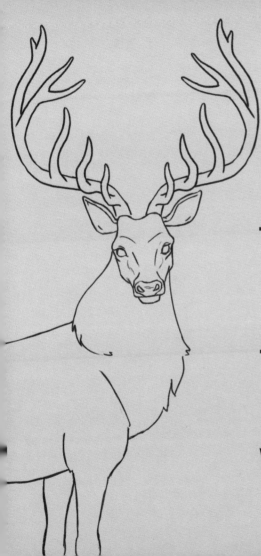

**A NASTY
LITTLE GOBLIN.**

**A GREAT STAG WITH
HUGE ANTLERS.**

**A LUMBERING,
DECAYING ZOMBIE
WITH A SAVAGE SNARL.**

A TERRIFYING GIANT SPIDER.

A DEADLY PREHISTORIC VELOCIRAPTOR.

THE HYENA QUEEN.

A WATCHFUL OWL.

A PARASITIC ALIEN.

A HUGE DRAGON,
WILD AND FIERCE.

A PLUMP
FARMYARD CHICKEN.

A SAVAGE BATTLE WOLF.

A CREATURE THAT
DWELLS IN THE SEWERS.

THE LEAST TERRIFYING
MONSTER EVER.

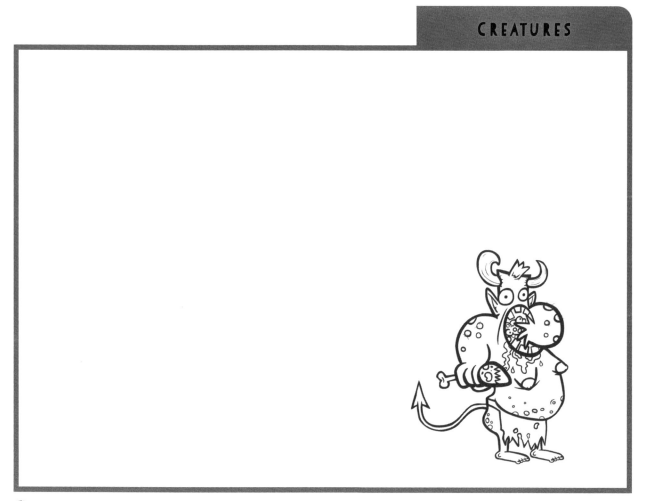

This monster is pretty scary – now draw his big brother, the MOST terrifying monster ever!

A HARPY, A MONSTROUS
MIX OF WOMAN AND BIRD.

THE GRIM REAPER WITH
HIS LONG, CURVING SCYTHE.

AN ADORABLE FOREST
ANIMAL-TURNED-ZOMBIE.

A MONKEY MARTIAL ARTIST.

A HERO'S CUTE ANIMAL SIDEKICK.

A SCIENTIST OF AN ALIEN
RACE, STUDYING HUMANITY.

A SKELETON WARRIOR.

OBJECTS

SILHOUETTING

As you grow as an artist and improve your technique, it is important to remember to always set the bar high and to keep pushing yourself to be better. If you feel that your artistic progression has got stuck, you would do well to remember that it is often the little things we practise that improve our skill.

To demonstrate exactly what I mean by this, I have chosen to show you a technique often used in the film and video game industries by concept artists: the silhouetting technique.

The premise of silhouetting is this: if your drawing was turned into a solid black form with no interior detail, would another person be able to clearly tell what it was? It is a simple technique that is easy to learn but it takes practice to perfect; if you master this method, it will add great value to your work.

Easy to pick up, difficult to master.

When drawing something, you want to make sure that what you are creating can be 'read' at a single glance. An easily recognisable shape is a crucial building block for a strong illustration – extra detail is just icing on the cake.

If there are multiple elements to a scene, could your audience differentiate them from each other based only on their form? Does the 'silhouette' look interesting and distinct? This technique can be applied to anything you draw, be it objects, characters, creatures, or environments.

FORM FIRST, CONTENT LATER

Let's consider a barbarian's axe. The best way to establish the effectiveness of an object is to first consider its silhouette. Look at the drawings below. Which is the best form to make this weapon look undeniably like an axe? By using the silhouetting technique you can ensure that your drawing has a strong, readable form that is interesting and unique. Once you find your best silhouette, use it as a guide and complete your drawing.

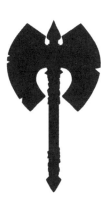

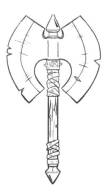

This could be an axe, a mallet, or a potato masher. It isn't very clear.

This silhouette looks like an axe, but it isn't very exciting or unique.

Now we're getting there: this axe is a little more exciting, but I think it could still be more fun to look at.

Yes! This silhouette is clearly an axe; it looks distinct and interesting.

The finished barbarian's axe.

DRAW YOUR OWN SILHOUETTES

Try the silhouette technique for yourself. Choose five different objects and draw a selection of silhouettes for each, focusing on improving the form each time to make it more readable and interesting. Here are a few ideas to get you started. Or just draw whatever takes your fancy.

Alien spacecraft.

Warrior's helmet.

Magic ring.

Wizard's staff.

Battle robot.

Hero's sword.

Exotic plant.

Musical instrument.

Child's toy.

Sci-fi gun.

A LEGENDARY SWORD.

A UNIQUE SPECIMEN
OF ALIEN PLANT LIFE.

A TALISMAN ON
A CHAIN. ITS GEM
GLOWS WITH POWER.

A DIABOLIC
BOOK OF SPELLS
BOUND IN CHAINS.

A TRAP SITS
OMINOUSLY
IN THE GRASS.

A STARSHIP
PILOT'S HELMET.

MULTIPLE POTIONS,
SMOKING WITH WISPY SWIRLS.

AN EVIL KING'S THRONE.

A DUSTY OLD TREASURE MAP.

Draw a cosy basket for this little kitty to take a catnap in.

A SHELF OF
MULTICOLOURED BOTTLES OF
VARIOUS SHAPES AND SIZES.

A STRANGE MACHINE FROM
A MAD SCIENTIST'S LAB.

A QUILL AND INKWELL.

AN ANCIENT BOOK ON
AN UNHOLY ALTAR.

A DEMONIC MASK.

THE WITCH DOCTOR'S
VOODOO DOLL.

109

A TAXI CAB FROM THE FUTURE.

A RARE FEATHER PLUCKED
FROM AN ELUSIVE BIRD.

AN ENCHANTED FIRE WEAPON.

AN ASSASSIN'S SLEEK,
POISONED DAGGER.

A FLAGON FILLED
TO THE BRIM
WITH GOLDEN MEAD.

A MONSTER'S CHEW TOY.

A PLATE OF
PANCAKES, PILED HIGH.

A RUG MADE FROM A
GREAT BEAST'S HIDE.

A SURVEILLANCE DRONE.

A SHINY COIN.

Draw an ornate bow and quiver.

AN ADVENTURER'S BACKPACK.

A SPILLED LEATHER SACK OF GOLD
COINS AND PRECIOUS JEWELS.

A HOT, STEAMING
BOWL OF RAMEN.

A FIGHTER SPACECRAFT.

A DRAGON'S NEST.

A CUDDLY STUFFED FOX.

A PAIR OF RUGGED LEATHER BOOTS.

A MONSTER-TOOTH NECKLACE.

A COWBOY'S PISTOL.

A CURVED, DOUBLE-EDGED
AXE WITH A LEATHER GRIP.

A STACK OF BOOKS.

A FRILLY CAROUSEL HORSE.

A MONSTER'S EGG.

A MESSAGE IN A BOTTLE.

A WOODEN BARREL.

A VIAL OF POISON.

A WITCH'S CAULDRON.

A WEAPON MADE FROM A
MONSTER'S TOOTHY JAWBONE.

A SPIDER ROBOT.

A MAGIC USER'S STAFF.

Draw the feast that fills the table surrounding this centrepiece.

A MAGICAL WISHING WELL.

A DRAGON'S SKULL.

A CASTLE GUARD'S CROSSBOW.

A ROASTED CHICKEN.

A STEAMPUNK GUN.

A MAGICAL RING.

A BATTLE MECH.

A BEARSKIN HAT.

A HEAVY BATTLE HAMMER.

A VIKING'S HORNED HELMET.

A DEMON'S HEAD
MOUNTED ON A PLAQUE.

A CROOKED, DEAD TREE.

Complete the unique staffs carried by these druids.

A HUNTER'S SPEAR.

A KING'S BANNER.

A WEDGE OF CHEESE.

A COMFY BED.

ANCIENT PROTECTIVE
RUNE STONES.

A HORSE'S SADDLE.

A RUSTY SKELETON KEY.

A GLOWING LANTERN.

A BOWL PILED HIGH WITH CANDY.

A CREEPY, OLD GRAVESTONE.

A VIDEO GAME SYSTEM
FROM THE FUTURE.

A FUTURISTIC MOTORCYCLE.

A PIRATE'S TREASURE CHEST.

A CHISELLED STONE STATUE.

A SUIT OF ARMOUR.

THE KING'S JEWELLED GOBLET.

A LUSH, RED ROSE.

Draw a spaceship going to or coming from this newly discovered planet.

A SPACECRAFT'S
CRYOGENIC SLEEP CHAMBER.

A HIGH-TECH CONTAINER
HOUSING A DEADLY PATHOGEN.

A STEAMPUNK TOP
HAT AND GOGGLES.

A FISHING LURE
DESIGNED TO CATCH AN
ENORMOUS SEA MONSTER.

A VAMPIRE HUNTER'S
ORNATE SILVER CROSS.

A WARRIOR'S WOODEN
SHIELD ADORNED WITH
A RAM'S SKULL.

ENVIRONMENTS

BACKGROUNDS MAKE YOU BETTER

When a young artist begins his or her drawing journey, more often than not he or she will start with character art, especially if interested in comic or manga-style mediums. Characters are the focal point of all stories, after all, and they are usually more interesting to draw than landscapes or inanimate objects. These characters are often drawn against the white of the paper or digital file and have little to no background.

While drawing characters without any kind of background is a perfectly fine exercise, I would caution against doing it *exclusively* if you hope to grow into a more confident artist. Not having to worry about a surrounding scene is a great way to practise figure drawing, anatomy and design; however, if you are interested in storytelling and creating a world involving your characters, drawing them in the context of a background is an essential exercise. Not only will your images

be significantly more interesting as a result, but a background scene will help you to vividly reveal the world your character resides in.

When an author is writing a novel, he or she is trying to create a living, breathing world that the reader is transported to. A good author can set up the scene so the characters are the focal point within a particular environment where the scene is taking place: wherever the scene may be – alleyway, grubby café, or fantasy kingdom – when you are taken there, you are much more engaged as a reader.

Settings are important because they communicate so much: they can set the tone and mood of a scene, they can influence a character's behaviour, and most importantly, they ground the author's vision into a reality that the readers can imagine. If an author fails to consider setting, a story won't be as believable as it could be.

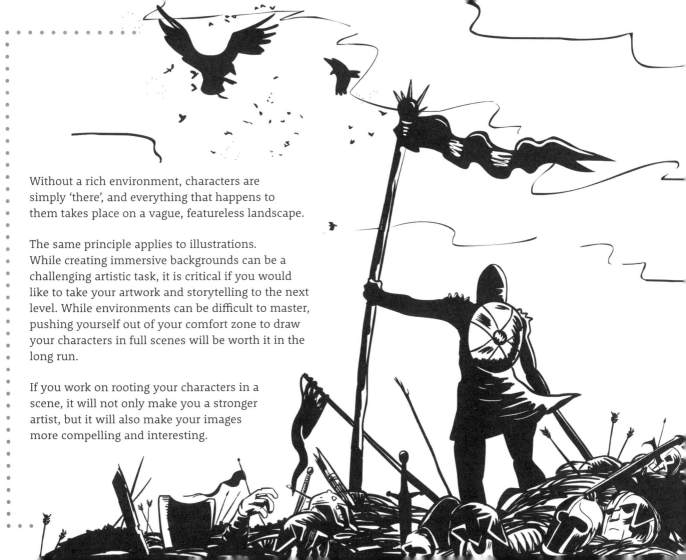

Without a rich environment, characters are simply 'there', and everything that happens to them takes place on a vague, featureless landscape.

The same principle applies to illustrations. While creating immersive backgrounds can be a challenging artistic task, it is critical if you would like to take your artwork and storytelling to the next level. While environments can be difficult to master, pushing yourself out of your comfort zone to draw your characters in full scenes will be worth it in the long run.

If you work on rooting your characters in a scene, it will not only make you a stronger artist, but it will also make your images more compelling and interesting.

PERSPECTIVE MADE EASY

'Perspective' is the term used for explaining how things are arranged in three-dimensional space when viewed from a particular point. Many beginner artists prefer to ignore the subject by avoiding drawing a scene or environment where perspective would be needed. If you want to be able to create cool backgrounds and exciting environments, having some grasp of perspective is crucial. It might appear intimidating, but I can assure you that it isn't so bad, and although it may seem complicated at first, it is an easy thing to grasp after a few tries. Over the next few pages I'm going to guide you through the basics of one-point, two-point and three-point perspective, and give you the opportunity to try each out for yourself.

ONE-POINT PERSPECTIVE

Imagine you are looking through the lens of a camera. One-point perspective is the view you'll see when using the camera to look straight down a railway track, a hallway or a city street, for example. There is only one 'vanishing point' in one-point perspective, and this is the point where all lines converge on the horizon.

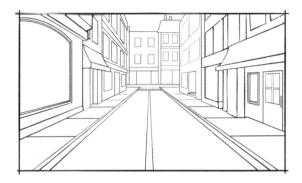

TWO-POINT PERSPECTIVE

Two-point perspective is much more commonly used than one-point perspective. It is a little more complex because, instead of facing objects straight on, our camera is slightly turned to one side. In one-point perspective, the camera was facing forwards so it looked down the street; in two-point perspective, the camera is turned to look down two streets at the same time and there are two vanishing points to which lines converge.

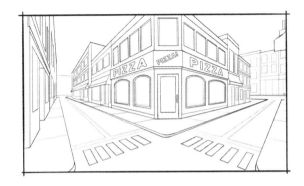

THREE-POINT PERSPECTIVE

Three-point perspective is similar to two-point perspective, but this viewpoint takes into account the slight distortion caused by looking up or down. It is slightly more complex, but you will notice a remarkable improvement in your ability to draw backgrounds if you can master it.

Three vanishing points are used in three-point perspective, but here is the catch: the third point does not rest on the horizon line with the other two; it is our vertical point and it usually lies far above or below the horizon line.

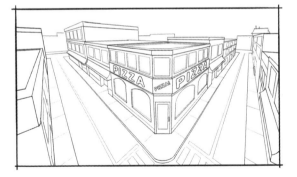

ONE-POINT PERSPECTIVE STEP BY STEP

Step 1 Draw a horizon line to represent the camera's eye level. Place a dot on the horizon line to represent the vanishing point.

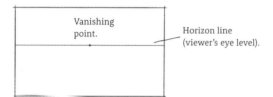

Vanishing point.

Horizon line (viewer's eye level).

Step 2 Draw some squares or rectangles in your scene.

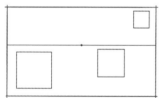

Step 3 Draw lines to connect the corners of your squares to the vanishing point. Using these lines as a guide, turn your squares into boxes.

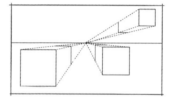

Step 4 Erase your guidelines and you have made a scene using one-point perspective. The practice example may just be a few cubes in a scene, but it is the basis on which to create much more complex scenes.

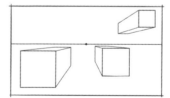

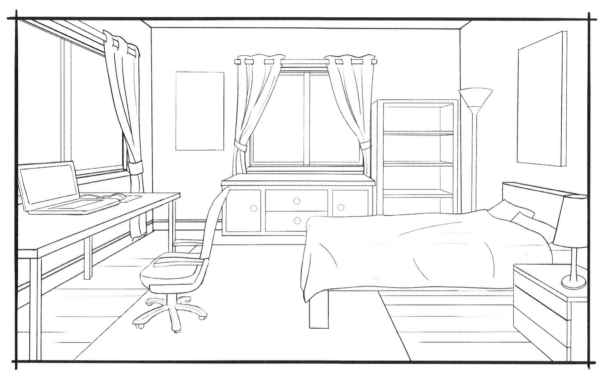

A bedroom scene in one-point perspective.

DRAW YOUR OWN ONE-POINT PERSPECTIVE

Now that you have learnt some basic perspective drawing, it is time for you to put it into action. In the frames supplied, draw a horizon line, a vanishing point and a few squares. Make those squares into boxes by drawing their edges going towards the vanishing point, following the one-point perspective step by step on page 136.

TWO-POINT PERSPECTIVE STEP BY STEP

Step 1 Draw a horizon line and two vanishing points. Draw several straight lines in the scene – these are the closest edges of your boxes.

Step 2 Draw your straight guidelines from the top and bottom of each edge line to the vanishing points. Use these guidelines to locate your other edges.

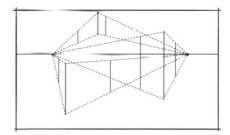

Step 3 Erase your guidelines. You're almost there; all that is missing is the top and bottom of some of the boxes.

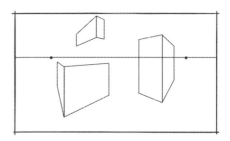

Step 4 To find the missing top and bottom, connect those edges to the vanishing point that they are not already pointing to.

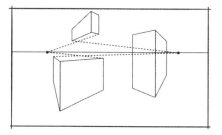

Step 5 Erase your guidelines and you have a scene in two-point perspective.

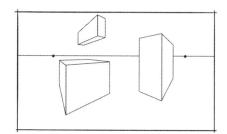

A bedroom scene in two-point perspective. It is the same scene as seen on page 137, except that now the camera view is rotated slightly to the right.

DRAW YOUR OWN TWO-POINT PERSPECTIVE

Two-point perspective is a little more challenging than one-point, but not by much. In the frames provided, draw a horizon line and two vanishing points. Follow the two-point perspective step by step on pages 140–141 to draw three separate boxes. Make sure each box has edges going to both vanishing points.

THREE-POINT PERSPECTIVE STEP BY STEP

Step 1 Draw a horizon line with two vanishing points. The third vanishing point lies between them, usually far above or below the horizon line. The further up or down the third point lies will affect the camera tilt. In this example, the third vanishing point is fairly close to the horizon line, so this scene will have a steep camera tilt. The further away it is, the shallower the tilt will be.

Step 2 Place an edge in the scene, making sure it lines up with the third vanishing point.

Step 3 Connect the ends of the edge to the vanishing points on the horizon line. Use the guidelines connected to the third vanishing point to find the angle for the sides.

Step 4 Erase your guidelines and you have a scene in three-point perspective. This angle looks down onto the cube. If the third vanishing point were placed above the scene, the camera would be looking upwards instead.

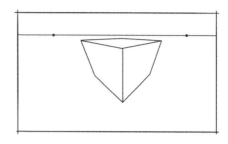

A bedroom scene in three-point perspective. It is the same scene as seen on pages 137 and 141, except now the camera view is tipped at a vertical angle, looking down on the scene.

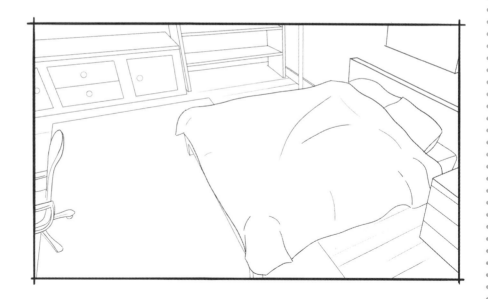

DRAW YOUR OWN THREE-POINT PERSPECTIVE

This is the most challenging perspective to master, but if you follow the three-point perspective step by step on pages 144–145, I have no doubt you can do it. In the frames, draw a horizon line with two vanishing points on the line. Then draw a third vanishing point well below the box and draw a few boxes in three-point perspective.

A DILAPIDATED
HAUNTED HOUSE
UNDER A FULL MOON.

A WIZARD'S
UNKEMPT LIBRARY.

A MISTY, MOONLIT
GRAVEYARD.

A BUSTLING, MODERN
CITY STREET.

A JAPANESE
SHINTO SHRINE.

AN UNDERGROUND
CAVERN ILLUMINATED
BY A VAST, GLOWING
BLUE LAKE.

THE SCENE OF A
CRASHED SPACESHIP.

THE OVERGROWN RUINS OF AN
ANCIENT STONE BUILDING.

A PREHISTORIC PET STORE.

THE GREAT
TOWERS OF A SCHOOL
FOR WIZARDS.

A QUAINT COTTAGE
IN A TRANQUIL
WOODLAND SETTING.

AN ALCHEMIST'S LAB.

THE KING'S STABLES.

A DANGEROUS, DARK ALLEY.

A GRAND BALLROOM.

IMMENSE ISLANDS FLOAT IN
THE SKY ABOVE THE FOREST.

Make this devillish character feel at home by creating a fiery environment for him.

A BARREN VOLCANIC
LANDSCAPE WITH ROCKY
FORMATIONS JUTTING SKYWARDS.

A MAGNIFICENT DINING HALL
WITH TABLES LAID WITH A
FEAST FIT FOR A KING.

A LAVISH CHURCH INTERIOR.

AN UNTRUSTWORTHY
ROPE BRIDGE SPANS A WIDE,
FAST-FLOWING RIVER.

A SUPERMARKET AISLE.

THE EERIE, DARK
SEWER TUNNELS.

A SHRINE NEAR THE
BASE OF A WATERFALL.

A SMALL WATERFALL STREAMS
FROM THE BLEACHED BONES OF
A GREAT BEAST'S SKULL.

SEEN FROM THE COBBLED STREET
OF THE SMALL MEDIEVAL TOWN, AN
IMPOSING CASTLE PIERCES THROUGH
THE DISTANT CLOUDS.

A SPACIOUS HANGAR FILLED
WITH BATTLE MECHS.

A MAGIC SHOP WITH A WIDE
SELECTION OF CURSED ITEMS.

A MYSTERIOUS CELLAR ILLUMINATED BY
TORCHLIGHT, FILLED WITH BARRELS OF
WINE AND OTHER SUPPLIES.

THE TOMB OF A GREAT DRAGON.

A LIGHTHOUSE ON A HILL
BY A SMALL HARBOUR TOWN.

A STATE-OF-THE ART GYM FILLED
WITH FITNESS EQUIPMENT.

A WARM, COSY COFFEE SHOP.

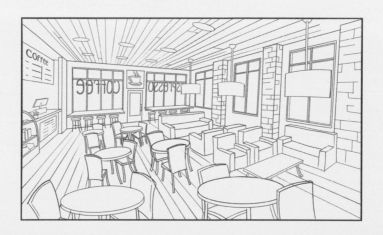

Create a futuristic world for little space guy to live in.

WISPY GREEN
SMOKE TRAILING
FROM A FRESH CRATER.

THE CLUTTERED DESK
OF A POTION MASTER.

A COSY CABIN IN
THE SNOWY WOODS.

A ROWDY TAVERN.

THE DESK OF A
COMPUTER HACKER.

TRAIN TRACKS RUNNING
PAST FACTORIES.

A PRISON CELL.

AN ARTIST'S STUDIO.

AN ARISTOCRAT'S
SUMMER RESIDENCE.

A RUTTED DIRT ROAD LEADING
TO A CREEPY, SOLITARY BARN.

AN ABANDONED
UNDERGROUND STATION.

A WITCH'S HOUSE.

AN OMINOUS FAIRY-TALE FOREST.

THE INSIDE OF A BULLET TRAIN.

A HIGH-TECH LABORATORY.

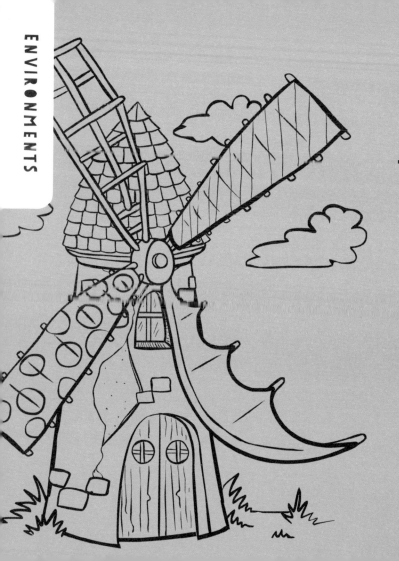

A SCI-FI CORRIDOR
LEADING TO
A LOCKED DOOR.

A CHILD'S DREAM
TREE HOUSE.

A WHIMSICAL
WINDMILL.

THE EMPEROR'S
TREASURE ROOM.

Draw the forest that this little owl lives in.

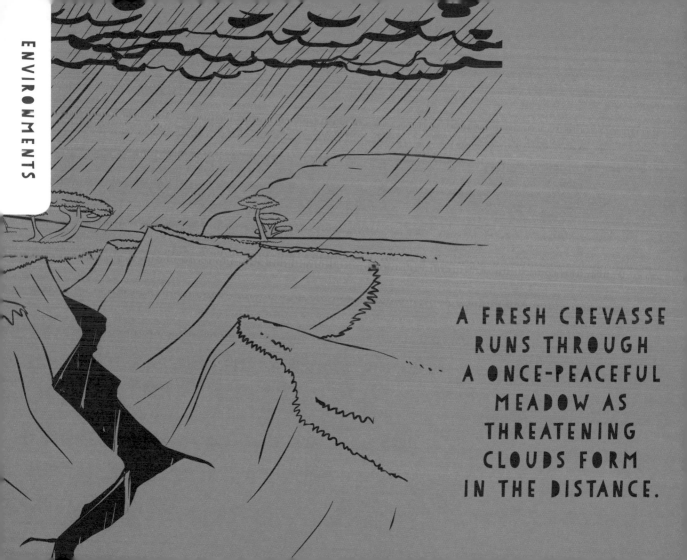

A FRESH CREVASSE
RUNS THROUGH
A ONCE-PEACEFUL
MEADOW AS
THREATENING
CLOUDS FORM
IN THE DISTANCE.

THE KING'S DUNGEON.

A FANTASY MARKETPLACE.

AN UNDERWATER KELP FOREST.

NATURE IS STARTING TO RECLAIM
THE ABANDONED CITY STREETS.

PUTTING IT ALL TOGETHER

Now that you have had some experience drawing captivating characters, extraordinary creatures, interesting objects and exciting environments, it is time to put them all together to create scenes of your own.

If you have read and followed the instructional exercises in this book, you'll have covered all the basics to enable you to meet my final challenge. But before you turn the page to reveal the task, there are a few techniques I would like you to recap on.

Be sure to draw your characters following the basic rules of body and head proportions (pages 10–23).

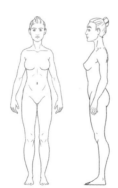

Pay attention to character detailing such as realistic hand construction (pages 24–27).

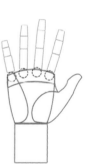

Pose your characters or creatures nicely (pages 28–31).

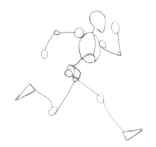

Don't be afraid to use reference if you feel you need to (pages 62–69).

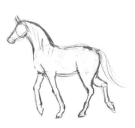

Decide what perspective to use when drawing environments or backgrounds (pages 136–147).

Use the strong silhouette technique to make your characters, creatures and objects impactful (pages 100–103).

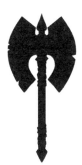

DRAW YOUR OWN SCENARIO

It is now time to put your hard work and drawing practice into action by combining everything you have learnt so far. Choose one or more of the situations below and use all of the techniques we have covered to create your picture on the opposite page.

Situation 1 A fireman climbs a ladder to rescue a kitten from a high tree branch.

Situation 2 A scuba diver exploring a beautiful coral reef takes a picture of a particularly stunning fish, unaware of the shark behind him.

Situation 3 In the dead of night on a lonely cobbled street, a sneaky goblin pickpockets a sack of coins from an unsuspecting victim.

Situation 4 In the dimly lit laboratory, a mad scientist mixes test tubes to create slime monsters.

THE ROPE WAS ABOUT TO SNAP.

OPENING THE CURTAINS
TO A BRIGHT NEW DAY.

'THE POTION SEEMS TO
BE WORKING. HE'S STARTING
TO CHANGE.'

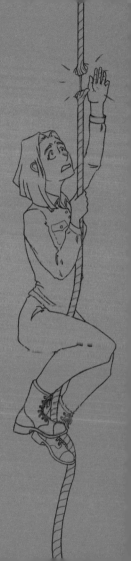

A CHASE ON HORSEBACK.

AN ALIEN ABDUCTION.

A YETI SIGHTING IN AN
UNUSUAL LOCATION.

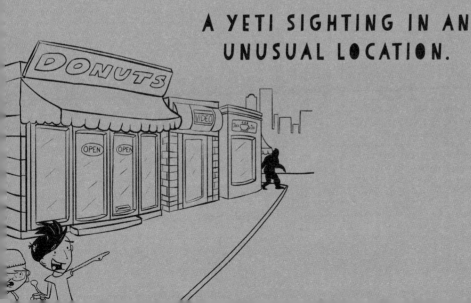

HE WAS SURROUNDED
BY FIRE BUT
REMAINED UNHARMED.

THE FACE IN THE
MIRROR WAS NOT HERS.

SHE WAS WALKING
THROUGH THE FIELD
WHEN SHE SPOTTED
SOMETHING UNUSUAL
IN THE SOIL.

AWAKENING AN ANCIENT
EVIL THROUGH A RITUAL
UNDER THE MOONRISE.

AN UNSUCCESSFUL
WEDDING PROPOSAL.

HE SAT ON THE BUS,
BLISSFULLY UNAWARE OF
THE STRANGE EVENT
HAPPENING BEHIND HIM.

'IT'S BEHIND
ME, ISN'T IT?'

'WAIT, YOU'RE TELLING
ME THEY EXIST?'

RUNNING TO
CATCH THE BUS.

HE DEFENDED
HIMSELF AGAINST
THE ATTACK.

The witch prepares her brew using a variety of nasty ingredients – draw her as she works.

FIRST KISS.

LOVE TRIANGLE.

FROM THE MOMENT HE
MET HER, HE WAS SMITTEN.

CAUGHT IN THE RAIN.

THEY WALKED HAND IN HAND,
FINGERS INTERTWINED.

A KNIGHT SAVING A DRAGON
FROM THE NASTY PRINCESS.

DOG ATTACK.

THE CHILD WAS BORN
WITH A UNIQUE
GENETIC MUTATION.

HE REMOVED HIS MASK.

SHE RAN THROUGH THE
WOODS FROM THE THING
THAT WAS CHASING HER.

SHE WAS HUMAN ONCE,
BUT NOW IS SOMETHING
ELSE ENTIRELY.

HE WAS HOT WITH FURY
AS HE DREW HIS SWORD.

HER BREATH SHOT A HAZE
OF STEAM OUT INTO THE
FROSTY MORNING AIR.

ENJOYING A HOT DRINK
ON A COLD WINTER'S DAY.

AFTER BEING CAPTURED BY
A CANNIBALISTIC TRIBE, THEY
KNEW THEY WERE IN TROUBLE.

A PRIDE OF LIONS
SURROUNDS A BROKEN-DOWN
SAFARI TOUR BUS.

WHO WOULD HAVE GUESSED THAT
THIS UNLIKELY PERSON WAS A
LEGENDARY DRAGON SLAYER?

THE LOST SHIP BATTLED
THE CRASHING WAVES.

SHE STOOD BEFORE A
MAGIC PORTAL, HESITANT
TO GO THROUGH.

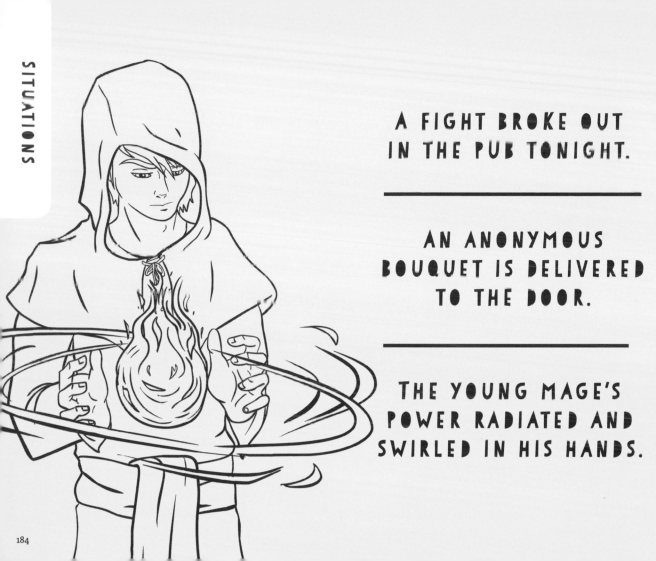

A FIGHT BROKE OUT
IN THE PUB TONIGHT.

AN ANONYMOUS
BOUQUET IS DELIVERED
TO THE DOOR.

THE YOUNG MAGE'S
POWER RADIATED AND
SWIRLED IN HIS HANDS.

The dog listens as his master's friends tell scary stories around a roaring camp fire.

THE DUELLISTS CIRCLED
EACH OTHER WARILY.

THE THIEF DELICATELY REMOVED THE
PRICELESS ARTEFACT FROM ITS STAND.

THE VEGETABLES HAVE COME ALIVE!

BASKING IN THE WARM SUN.

SAVED FROM A SCARY MONSTER
BY AN EVEN SCARIER MONSTER.

A STALEMATE WHERE EVERYONE
HAS A WEAPON POINTED AT THEM.

THE HERO HAS JUST HAD A NARROW SCRAPE WITH DEATH.

TOO MUCH COFFEE!

AN AWKWARD HUG.

GRANDMA TAKES
HER LEISURELY SUNDAY DRIVE . . .
ON HER HARLEY-DAVIDSON.

LIGHT RADIATED FROM HIM.

SHE BITTERLY REGRETTED EVER
AGREEING TO THIS BLIND DATE.

WHAT YOU HAVE LEARNT

My purpose in writing this book has been to create an informative resource for learning drawing fundamentals and new techniques, as well as to provide an imaginative way to break 'artist's block' with fun drawing prompts.

We have covered a lot of material including drawing practice for some really important technical skills, such as the measuring of body and head proportions, the construction of human hands, and the basics of figure posing. You've also learnt the basics of the three main environment perspectives (which is no small feat) and how to apply them to your own scenes. You have even spent some time learning how to make things look more interesting by tweaking their silhouettes. But there is a lot of good non-technical advice in this book, too. Listed right are five things you should never forget.

I hope you use the prompts to inspire you to draw lots of fun new things, and be sure to share your art with us – and get more prompts! – at www.Artprompts.org.

Practice makes perfect There is no way around the fact that if you want to be great at drawing, you have to draw a lot, with deliberate focus and a drive to improve.

Step out of your comfort zone Use plenty of reference and know that your first attempts at drawing new things might not turn out very well.

Don't quit It's easy to get frustrated, but just keep practising and you will improve.

Draw your heart out Emulate your favourite artists, but don't just copy them – develop your own style.

Keep motivated If you're having trouble staying focused, employ my discipline tips (see page 9).

ABOUT THE AUTHOR

Taylor McNee hails from Alaska and lives in Idaho (USA) with her husband Bret, daughter Riley and two dogs. She is a 3D artist in the video game and film industry and an avid doodler. Taylor developed www.Artprompts.org as a fun resource for those who are looking to improve their artistic skill set or for those who are suffering from 'artist's block'. She would love you to stop by her website!

Dedicated to my
wonderful husband
and my beautiful
baby girl.

First published in the United Kingdom in 2016 by
Portico
1 Gower Street
London
WC1E 6HD

An imprint of Pavilion Books Company Ltd

ISBN 978-1-91104-224-2

A CIP catalogue record for this book is available from the
British Library.

10 9 8 7 6 5 4 3 2 1

Reproduction by Mission Productions Ltd,
Hong Kong.
Printed and bound by 1010 Printing International Ltd, China

This book can be ordered direct from the publisher at
www.pavilionbooks.com